DOUBLE EXPOSURE

PICTURES WITH PURPOSE

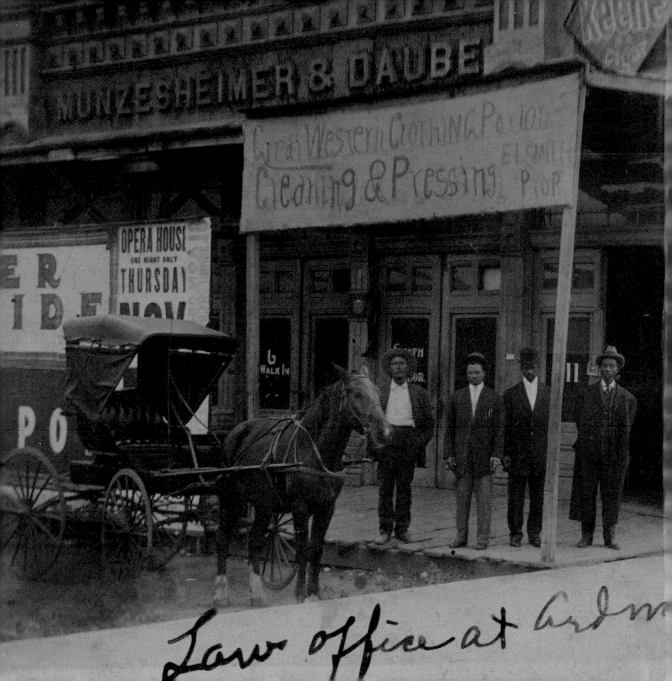

DOUBLE EXPOSURE

PICTURES WITH PURPOSE

Early Photographs from the
National Museum of African American History and Culture

Earl W. and Amanda Stafford
Center for African American Media Arts

GILES

National Museum of African American History and Culture
Smithsonian Institution, Washington, D.C., in association with D Giles Limited

For the National Museum of African American History and Culture
Series Editors: Laura Coyle and Michèle Gates Moresi

Project Coordinator: Douglas Remley

Curator and Head of the Earl W. and Amanda Stafford Center for African American Media Arts: Rhea L. Combs

Publication Committee: Aaron Bryant, Rhea L. Combs, Laura Coyle, Michèle Gates Moresi, Loren E. Miller, Douglas Remley, Jacquelyn Days Serwer, and Margaret Wessling
This project is supported by the Phillip and Edith Leonian Foundation.

For D Giles Limited
Copyedited and proofread by Jodi Simpson
Designed by Alfonso Iacurci
Produced by GILES, an imprint of D Giles Limited
Bound and printed in China

All measurements are in inches and centimeters; height precedes width precedes depth.

Photograph titles: Where a photographer has designated a title for his/her photograph, this title is shown in italics. All other titles are descriptive, and are not italicized.

This book contains graphic images of violence that may not be suitable for younger or more sensitive viewers.

Front cover: Three women seated, 1870s (detail), Unidentified photographer
Back cover: Frederick Douglass, 1855–65, Unidentified photographer
Frontispiece: B. C. Franklin and unidentified men in Ardmore, Oklahoma, 1910 (detail), Unidentified photographer
Page 6: A woman in a striped dress, 1890s (detail), Unidentified photographer

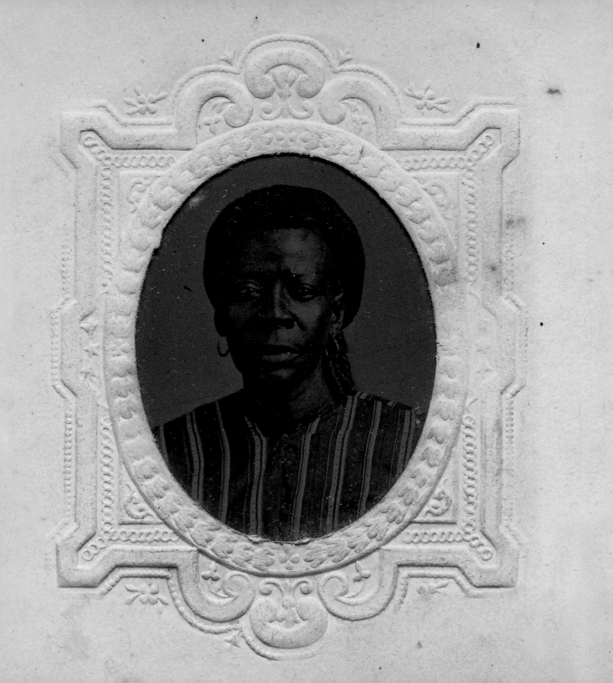

Foreword

The photography collection at the National Museum of African American History and Culture documents, celebrates, and explores the lives and stories of black people in the United States and beyond. The photographs selected for this seventh volume of the *Double Exposure* series bear witness to African Americans during a crucial span of history, from the dawn of photography in the United States through the Civil War and its aftermath. This book also includes images from the decades that followed Emancipation, when Americans of different races and politics sought to understand and define what it meant to be an American. *Pictures with Purpose* focuses a lens on African Americans, not merely as subjects, but also as agents. African Americans are depicted as makers of change, defining the direction of their own lives and determining their own destiny.

An important role of this Museum is to help all Americans to remember the diversity among those who founded and built this nation. How the past is documented shapes how we remember it. One of the most crucial means of documentation is photographs of people. Much of the life and history of ordinary African Americans is not well known, and photographs can help fill in crucial gaps. Many of these photographs can be associated with a time and place, so even if the sitters cannot be identified, these images contribute to our understanding of the communities they represent.

Collecting these images is also a project to recover memory. The names of many thousands of black people who survived slavery and endured its aftermath are lost today, but images of them restore their dignity and convey their humanity (opposite). These images often combat stereotypes. Although many African Americans, both formerly enslaved and free, and their descendants did end up working hardscrabble lives, especially in the agricultural South, photographs provide proof, in the way the sitters presented themselves, that other African Americans all across the country were not merely subsisting but striving for, aspiring to, and achieving middle-class lives. We have such photographs from the period taken in California, Connecticut, Montana, New York, South Dakota, and Tennessee.

Frederick Douglass, Sojourner Truth, and W. E. B. Du Bois were early enthusiasts of photography. They consciously used pictures in addition to words to create counter-narratives to mainstream depictions that relegated African Americans to one-dimensional stereotypes and gross characterizations. In so doing, they left us a counter-history. Their use of photography has

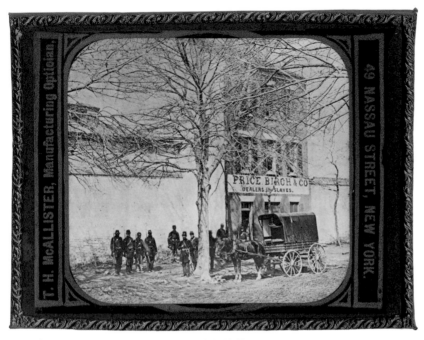

Slave dealers Birch & Co. in Alexandria, Virginia, 1862
Mathew Brady

a parallel in the ways ordinary people used pictures to create the narratives of their own lives. Consequently, both well-known historic figures and regular people influenced what we remember about African Americans today, and how we remember them.

In collecting images of the past, it is imperative to preserve evidence of ugliness. This volume includes depictions of lynchings and other difficult subjects as reminders of the racism and violence many African Americans suffered as they tried to build better lives. Some of the photographs depict the grisly violence committed on black bodies and are in stark contrast to dignified portraits of African Americans also presented. However, these ghastly images are necessary to force a recognition of hard truths about America, to remember and honor those who suffered, and to compel continuing fights for justice today.

This volume includes two powerful essays that highlight and examine the early photographs in the Museum's collection. *The Social Lives of Photographs* by Laura Coyle

and Michèle Gates Moresi focuses on how Americans approach photography as a social practice and frames the presentation of the photographs in the book. Tanya Sheehan contributes a thoughtful essay on vernacular photography and what it can tell us about the African American experience.

The Museum is dedicated to documenting diverse experiences that allow us to view American stories through an African American lens. The Museum's collection of early photography supports the innovative programming of the Earl W. and Amanda Stafford Center for African American Media Arts (CAAMA). CAAMA, as a physical and virtual resource within NMAAHC, exemplifies the Museum's dedication to preserving the legacies of African American history and culture. We are grateful for the support of the Phillip and Edith Leonian Foundation in caring for the photographs included in this volume and supporting CAAMA programs featuring early photography topics.

Many other people collaborated on this important book and landmark series. At the Museum, special acknowledgement is due to the publications team: Jacquelyn Days Serwer, Chief Curator; Michèle Gates Moresi, Supervisory Museum Curator of Collections; Laura Coyle, Head of Cataloging and Digitization, who serves with Michèle as co-editor of this series; Rhea L. Combs, Supervisory Curator of Photography and Film and Head of the Stafford Center for African American Media Arts; Aaron Bryant, Curator of Photography; Douglas Remley, Project Coordinator; Loren E. Miller, Curatorial Assistant; and Margaret Wessling, Conservator of Photographs. Ongoing support and encouragement from our Associate Director for Curatorial Affairs, Rex Ellis, has been invaluable to the continuation of the series.

We are also very fortunate to have the pleasure of co-publishing with D Giles Limited, based in the UK. At Giles, I particularly want to thank Dan Giles, Managing Director; Alfonso Iacurci, Designer; Allison McCormick and Louise Parfitt, Managing Editors; Louise Ramsay, Production Manager; Jodi Simpson, copyeditor and proofreader; and Liz Japes and Karen Lunstead, Sales and Marketing Managers. Finally, I would like to thank our entire Digitization Team for researching, cataloging, digitizing, and preparing all of the images and captions included in this volume.

I am proud to continue this landmark series of publications with early photographs that help document and illuminate the American experience. I hope you will be moved by these images.

Lonnie G. Bunch III
Founding Director
National Museum of African American History and Culture, Smithsonian Institution

The Social Lives of Photographs

Laura Coyle and Michèle Gates Moresi
National Museum of African American History and Culture

From the moment photography arrived in the United States in 1839, African Americans seized it as a powerful tool for shaping, sharing, and preserving their image. Providing highly realistic, tangible, and lasting images, photographs were immediately marshaled as compelling evidence about the people, places, and events captured in them. African Americans used this evidence to challenge their misrepresentation by mainstream society, even as others used it to perpetuate stereotypes. Recognizing these competing motives, in this essay we focus on how Americans approached photography as a social practice—one that involved the photographers, subjects, clients, collectors, senders, sellers, publishers, and consumers—and on what these photographs can reveal about the past.

This volume features images captured with a range of techniques and media: daguerreotypes, ambrotypes, and tintypes enclosed in sturdy cases; photographs on paper, some mounted on small cards, called cartes-de-visite, and larger cards, called cabinet cards; postcards; lantern slides designed to be projected; and stereographs, which use a special viewer to make images appear three-dimensional. Despite their variety, most of the photographs represent people. Americans coveted portraits, and photography quickly made the genre widely accessible.

The photographs in this book are organized by sections that are tied to one of several original purposes of the images: claiming identity, commissioning black photographers, persuading the public, documenting everyday life, commemorating achievements, and preserving memories. Each section allows us to explore the photographs' role in society as well as what they can tell us about that period in American history.

Claiming Identity

The portrait photograph provided a new means of self-expression, a way to declare one's place in society and assert an individual identity. African Americans used photography to shape their image, consciously seeking out and collaborating

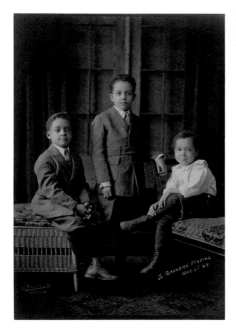

*Robert, Addison F., and
George Scurlock,* 1924
Addison N. Scurlock

she called her photographs, to support her political work. Truth's portraits also strongly countered white writers who depicted her as a naive, exotic African.[1] Douglass, known as the most-photographed person of the nineteenth century,[2] sat for over 150 portraits, each a powerful picture of a dignified, self-determined black man, and each a promise of what freedom and citizenship would bring to African Americans. Like his prolific writing and powerful oratory, these photographs served his activism.

Commissioning Black Photographers

African Americans were among the first photographers in the United States. Some white photographers created sympathetic portraits of black people. However, black photographers shared a personal stake in portraying black subjects respectfully, and in affirming the worth not only of each person, but of the entire race.

The earliest photographic process popularized in the United States was the daguerreotype, which produced mirrorlike images in extraordinarily fine detail. Deborah Willis has documented fifty black daguerreotypists who operated studios in American cities.[3] Two of these pioneers, Augustus Washington and James Presley Ball, are represented in the National Museum

with photographers to present and see themselves as they wished to be seen.

This is clearly evident in the portraits of Sojourner Truth and Frederick Douglass (see pp. 24–25), who transformed themselves by escaping from slavery and becoming key figures in the abolitionist movement. Just as they promoted their life stories with published biographies, they seized control of their photographic images and used them to speak directly to their audiences. Dressed conservatively for the camera, Truth carefully crafted an image of a pious, decorous woman. She sold her "shadow," as

of African American History and Culture's collection. Although daguerreotypes were fragile, they were usually encased so that they could be handled and travel more safely. At home or on the road, these photographs helped people remember those who were important to them and, when shared, prompted stories about them. Because these images were not easily reproduced, viewing them likely occurred primarily within family or social circles.

In the early twentieth century, many black photographers committed to the powerful idea of the New Negro. Promoted by intellectuals such as Alain Locke and W. E. B. Du Bois, the New Negro had at its core race pride, self-reliance, and the expectation of equal rights. Elsewhere in this volume, Tanya Sheehan discusses the work of black photographers such as Cornelius M. Battey, Arthur P. Bedou, John Johnson, and Addison N. Scurlock, whose photographs of men, women, and children embodied racial pride. Many were reproduced widely in the black press and were intended to provide models for black audiences.

Persuading the Public

In 1861, Frederick Douglass warned that photography, as a social force, could "either lift us to the highest heaven or sink us to the lowest depths."[4] Photographers created thousands of positive images of African Americans that challenged racial stereotypes and projected new black personas. Many of the photographs in this book attest to black talent and achievement, such as the silver gelatin print of the Negro String Quartet (see p. 43). These images inspired African Americans and offered white audiences positive views of black life.

However, in the public arena, photographs of African Americans were also used to exploit mainstream tastes for the "exotic" or "primitive," perpetuate stereotypes, and promote racist agendas. When African Americans were dehumanized or presented as economic, social, or sexual threats in photographs, those images sometimes moved people to violence and were used to justify physical attacks on black people. Still other pictures chronicled white violence against African American citizens (see pp. 48–51). Saved as souvenirs and circulated as postcards, photographs of lynchings and decimated black communities reinforced notions of white superiority.

Documenting Everyday Life

As important as it is to remember the reality of that violence, it is mercifully eclipsed by photographs in the Museum's collection of more positive aspects of everyday black life.

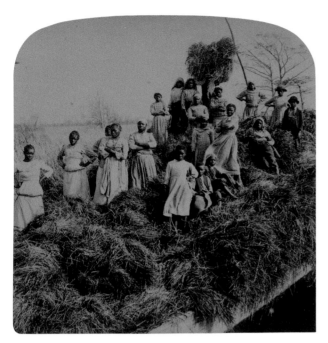

A Rice Raft, South Carolina, 1895; printed 1904 (detail)
Strohmeyer & Wyman

Like other Americans, African Americans used photography to record images of themselves as they were and as they aspired to be. Thus the newspaperman and hotel porter joined with photographers to portray themselves as dignified working people (see pp. 54–55). Such pictures present not only the daily, external lives of African Americans, but also their interior lives. They show us how African Americans forged on with dignity, not allowing racism to prevent them from making their lives the best they could be.[5] We see in these photographs people as they lived and worked in their segregated communities, providing one another with the services they needed and supporting the activities that sustained them.

Experiencing rapid social changes due to mechanization, industrialization, and urbanization, the American public in the second half of the nineteenth century was hungry for photographs that explained their world. It was in this context that the stereograph became a popular form of education and entertainment. By purchasing a stereoscope and sets of stereograph cards from commercial firms, Americans could virtually experience landscapes they could not visit and encounter people they had not met. Many of these post-Emancipation photographs show African Americans at work in the landscape, no longer as enslaved workers but often as sharecroppers.

In the detail above of plantation workers on a raft, we see women, young girls, and boys looking at the camera, dutifully posing. The caption on the back reads, "Negro hands do most of the work.... These mammies and darky maids are indispensable helps in handling the crop—one of the state's most valuable productions." While these words

13

promote commonly held stereotypical views of black laborers, they acknowledge the work African Americans provided to sustain rice production, an economic mainstay of the region. Consumers of the card may also have focused on the people in these images—the "mammies" and "darkies"— recognizing them as actual people who endured harsh working and living conditions. These figures confront us with direct gazes; some stand with arms crossed or hands on hips, daring us to ignore them.

Commemorating Achievements

Marking lifetime milestones and personal achievements is another way photographs served African Americans' desire to be seen as persons with dignity. Portraits honor United States military service, affirm vocations, recognize leadership, and celebrate educational attainment. One of the more remarkable photographs in the Museum's collection commemorates Thomas Mundy Peterson, the first African American to vote under the Fifteenth Amendment (see p. 61). The Museum also owns a marriage certificate with portraits (see p. 66), significant because marriage was only newly accessible to many African Americans who had been denied civic recognition of their unions under slavery.

Preserving Memories

Americans collected photographs to enjoy and share images of what was important to them. Browsing photographs at home with friends and family was a pleasurable pastime, an occasion for transmitting values as well as personal and family histories. Photograph collections also empower people to preserve their stories for the future. Today, early collections provide a unique window into the lives of both photographic subjects and collectors.

Personal photograph collections usually present an aspirational or idealized version of people's lives, and precise information about the photographs—who took them, who owned them, who they represent, when they were taken, where they were taken, and why they were taken—can be fragmentary or missing. Nonetheless, collections created by African Americans are valuable today because they help restore people to their rightful place in history. At the same time, they challenge assumptions that black communities in the late nineteenth and early twentieth centuries were impoverished and socially inferior. A good example of both is the turn-of-the-twentieth-century album associated with Waterbury, Connecticut, which provided the impetus to rediscover and document the small but vibrant and

self-reliant African American community that resided there (see pp. 74–75).

The Museum owns other notable collections, including two featured in this book. One is an album owned by a white Quaker educator, Emily Howland, which includes the earliest known portrait of Harriet Tubman (see pp. 70–73). The album expresses Howland's anti-slavery activism and helped her share her ideas with those in her orbit. Now the album helps us to better understand interracial efforts to abolish slavery and to educate freed people. The second contains the photographs amassed by Dr. Arthur Melvin Townsend Sr., a physician, educator, and community leader in Nashville, Tennessee, for sixty years (see pp. 76–77). The photographs allowed him to remember and share the impact he had on his community and helped ensure this would not be forgotten.

This publication documents the many ways early photographs of African Americans played a social role in America. Those who commissioned, created, collected, shared, and disseminated these pictures held various attitudes toward black Americans, influencing how African Americans were represented. The photographs, in turn, shaped viewers' ideas about black people. In some cases, white photographers created images that exploited stereotypes. Using the same tool,

African Americans confronted prejudice by commissioning and creating their own images.

These self-affirming photographs surely had a significant impact on African Americans. They declared black people's worth, both as individuals and as a group, within a larger society that often denigrated them. The exact meaning of any image is personal, but in viewing dignified portrayals of themselves, African Americans must have found inspiration, pride, and solace. Today, these pictures are still captivating, encouraging us to celebrate the agency and aspirations of legions of black people, behind and in front of the camera.

Endnotes

1. Nell Irvin Painter, "Sojourner Truth in Life and Memory," *Gender & History* (Spring 1990): 3–16.
2. John Stauffer, Zoe Trodd, and Celeste-Marie Bernier, *Picturing Frederick Douglass: An Illustrated Biography of the Nineteenth Century's Most Photographed American* (New York: W. W. Norton & Company, 2015).
3. Deborah Willis, *Reflections in Black: A History of Black Photographers 1840 to the Present* (New York: W. W. Norton & Company, 2000).
4. Frederick Douglass, "Pictures and Progress," in Stauffer, Trodd, and Bernier, *Picturing Frederick Douglass*, 171.
5. Robin D. G. Kelley, "Foreword," in Willis, *Reflections in Black*, ix–x.

Vernacular Photography: A Plurality of Purposes

Tanya Sheehan
Colby College

Commercial studio portraits, amateur snapshots, stereographs, and a variety of everyday photographs—known collectively as vernacular photography—can tell us much about the African American experience. Treated as distinct from artistic production, this popular genre of images has been said to capture the essence of black lives and identities.[1] The collection of early photographs in the National Museum of African American History and Culture reveals, however, that the vernacular encompasses a significant range of purposes. Indeed, many motivations shaped the creation, dissemination, and consumption of the images in this book. While most aimed to preserve likenesses and memories, honor individuals, and uplift the black race, others reinforced racial stereotypes and challenged black agency.

It is not always easy to determine the purpose a vernacular photograph once served, especially without information about its making and ownership. We must embrace that ambiguity as an opportunity to look closely and recognize the possibility of multiple purposes, even within a single image. Take, for instance, two of the oldest photographs in the Museum's collection, a tintype (opposite left) and a daguerreotype (opposite right). In each, an unidentified black woman sits with a young child for an unknown commercial photographer. The two conventional studio portraits also resemble each other in the direct gaze, close-lipped expression, nearly frontal pose, fine dress, and tender embrace of the child. Printed directly on thin sheets of metal, the photographs are similarly framed by a brass mount edged by red velvet and set within a case meant to be cradled in one's hand, opened for viewing, and then latched shut. These intimate pictures, which capture precious moments of childhood, would have been valued highly by the Americans who first owned them.

Despite their many points of connection, we cannot assume the two photographs were commissioned for the same purpose. The white masters of slaves and servants usually instigated portraits that paired their children with the black women who cared for them. In the antebellum United States, however, the

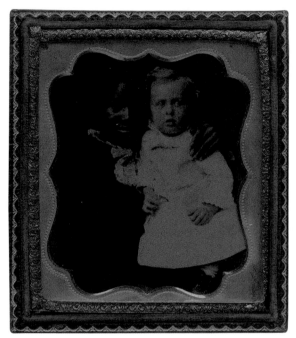

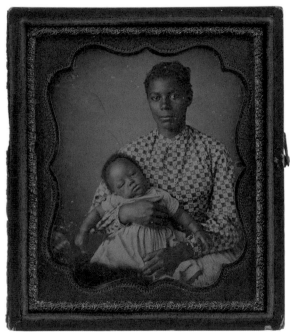

A woman with a child, ca. 1865
Unidentified photographer

A woman with a child on her lap, 1839–65
Unidentified photographer

17

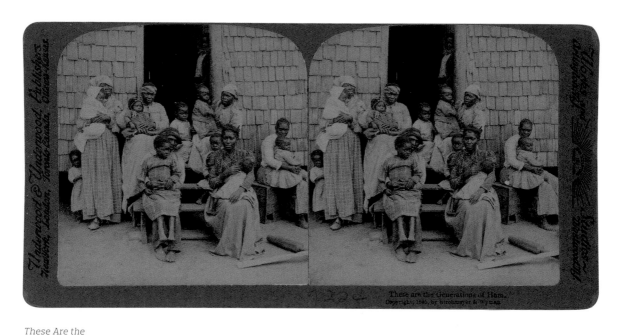

*These Are the
Generations of
Ham*, 1895
Underwood
& Underwood

socially dominant figure in the relationship was imagined to be the child, who symbolized the prosperity of the white bourgeois family. Note that the young boy in the cased tintype stands, literally dominating the scene, while the woman sits. Observe, too, that the photographer took special care, through lighting and exposure, to privilege the features of the light-complexioned toddler over those of his dark-complexioned caretaker, as was the convention of the period. The purposes of the daguerreotype are less clear. Did a free woman or her family contract a photographer to create a venerable image of motherhood for their own consumption? Or is this another instance of a white family seeking to represent a subservient black woman, as certification of their social power? We might also be looking at something between these two possibilities: a white master may have paid for the image to document the fine condition of his property, and in effect justify enslavement, or the woman in the daguerreotype could have shared it with distant relatives, using it to maintain family bonds and communicate affection.[2]

There is no such ambiguity of purpose in the stereograph titled *These Are the Generations of Ham* (opposite), one of approximately 150 photographic stereographs in the Museum's collection. Between the 1850s and 1920s, this popular format was consumed in the domestic parlors of a predominantly white middle class. A binocular instrument known as a stereoscope enabled the two photographs on the card to appear as a single three-dimensional image. In this example, nineteenth-century viewers would have been entertained by an image of stereotypical rural Southern black life in which women, children, and one man pose idly alongside a crudely shingled structure. The card's title invokes Genesis 9, wherein Noah curses the descendants of his son Ham to eternal servitude. Equating Ham's "darkness" with the blackness of Africans, white Americans embraced this biblical story as a rationalization of racism and slavery. It was a myth in which they invested well after Reconstruction, as evident in the earliest publication of this stereograph in 1895.

Although far from truthful representations of African Americans, stereotypical images belong in the Museum's collection because they were the dominant means of representing black people for much of photography's—and America's—history. The stereographs here and on page 40 ultimately reveal more about whiteness than blackness, insofar as they express white anxieties about "others." For this reason, they must be read alongside the contemporaneous honorific

portrayals of black subjects that fill this book, which tell very different stories of African American resistance and resilience.

We can look to black photographers for such stories. Early portrait studio owners Augustus Washington and James Presley Ball, for example, built careers on picturing everyday people presenting their best selves for a friendly camera (see pp. 32–33). Others, such as Cornelius M. Battey (opposite) and Arthur P. Bedou (see p. 36), are best known for photographing prominent African Americans at the turn of the twentieth century. Battey's celebrated portraits of African American leaders were created to publicize widely the self-determination of these leaders and make visible their messages of racial uplift. Battey accomplished these goals in part by adopting elegant poses and a soft focus associated with the pictorialist movement, thereby challenging the assumption that vernacular photographs eschew artistry. The photographer also attributed his success in representing black subjects to his racial identity, writing in 1911 to Booker T. Washington at the Tuskegee Institute (see p. 38), "Can it be possible for one of the opposite race to picture truthfully the history of our primitive examples since slavery, living outside our horizon, as well as one who is bone and sinew of this people?"[3]

Battey put this question to the test in 1920 when turning to the vernacular subject of *The Sharecropper*. Unlike the many stereographic photographs of laboring black bodies in the American South (see pp. 56–57), this image is neither an unfeeling document nor a biting joke but a sympathetic, aesthetically lit, close-up portrait of an aged man in tattered clothes, focused on the work in his hands. By rendering the former slave, now tenant farmer, as poor yet dignified, Battey offered his black audience an artful remaking of the stereotypical image of the Old Negro.

Sixty photographs in the collection, taken by John Johnson in Lincoln, Nebraska, between 1910 and 1925, show how a local, self-taught photographer shared Battey's mission and helped forge the image of the New Negro. Church groups, social clubs, local business owners, laborers, families—virtually everyone Johnson knew in the tightly knit black community of Lincoln stepped before his lens. Like fashionable studio photographers of his day, but operating largely outdoors with a bulky view camera, Johnson set out to present sitters as beautiful, proud, and middle class. Finely attired couples seated on their front porches, children standing obediently beside bicycles or phonographs, and young women in well-appointed parlors—

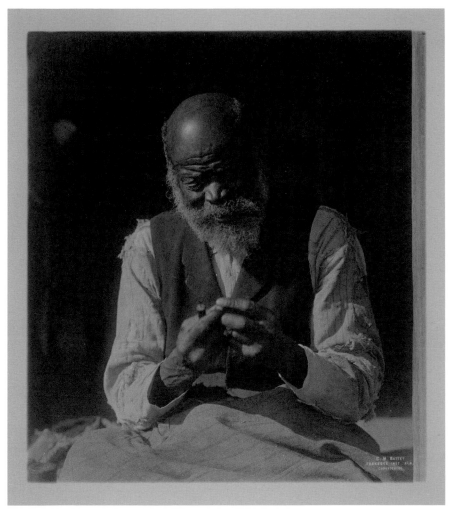

The Sharecropper, 1920
Cornelius M. Battey

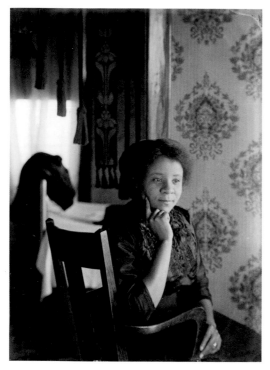

Frances Hill sitting in a chair,
1919–25; scanned 2012
John Johnson

all captured by Johnson—express black domesticity, modernity, and prosperity.[4] His portrait of Frances Hill engaged in thoughtful introspection depicts the sitter and her community as sophisticated and confident. His artistic choices in dress, pose, and setting bring to mind the work of Johnson's better-known contemporaries, such as Addison N. Scurlock in Washington, D.C. (see pp. 11, 35, and 39).

In the photographs of Johnson and Scurlock we can find the fullest realization of photography's social value in the African American community, but not its origins. As the abolitionist Frederick Douglass recognized in a series of lectures in the 1860s, the medium places the power to make pictures in the hands of all Americans and thus lends them the capacity to fashion more accurate and desirable images of themselves. Such re-presentation, he believed, would dispel prejudices, propagate freedom, and enable social progress. The Museum's collection reminds us that these critical goals constitute photography's highest purpose.

Endnotes

1. Brian Wallis and Deborah Willis, *African American Vernacular Photography: Selections from the Daniel Cowin Collection* (New York: International Center of Photography, 2005).
2. See the case of Louisa Picquet in Jeanne Moutoussamy-Ashe, *Viewfinders: Black Women Photographers* (New York: Dodd, Mead, 1986), 6–7.
3. Battey to Washington, November 26, 1911, reel 325, Booker T. Washington Papers, Division of Manuscripts, Library of Congress, quoted in Michael Bieze, *Booker T. Washington and the Art of Self-Representation* (New York: Peter Lang, 2008), 73.
4. Jennifer Hildebrand, "The New Negro Movement in Lincoln, Nebraska," *Nebraska History* 91 (2010): 166–189.

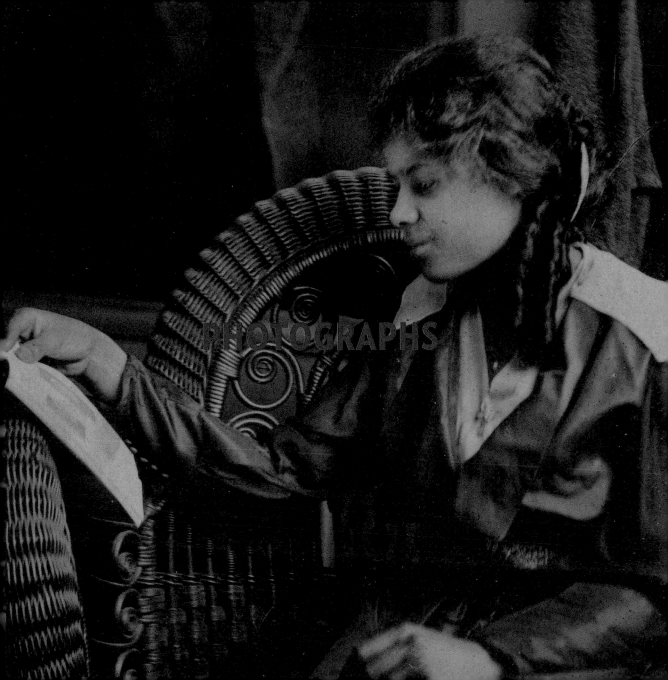

CLAIMING IDENTITY

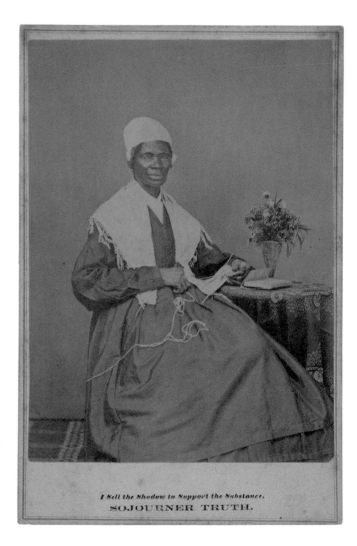

Sojourner Truth, 1864
Unidentified
photographer

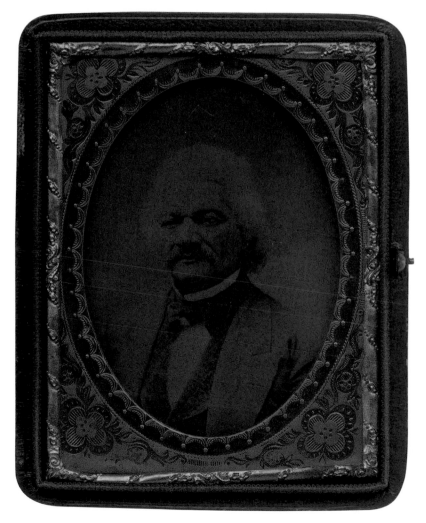

Frederick Douglass,
1855–65
Unidentified
photographer

Sarah Ann Blunt Crozley, 1884
Carter

—

Sarah Ann Blunt Crozley claimed her identity by dictating her biography, by the way she dressed, and by having her photograph taken. She was born around 1820, on the Eastern Shore of Maryland. According to Crozley, her mother's grandfather was a king in Africa and her father's ancestors lived in Madagascar. She spent much of her early life enslaved in Baltimore but was sold and sent to Louisiana in 1846, where she worked on a sugar plantation for fifteen years. It was there that she was probably required by law to wear a tignon, a type of turban. In defiance of these laws, some women of color wore fancy tignons. Crozley married Joseph Blunt, with whom she raised three children. By 1878, she had moved north to Connecticut, then settled in Worcester, Massachusetts. Crozley may have worn a tignon in this photograph to signal her time in Louisiana and her African heritage.

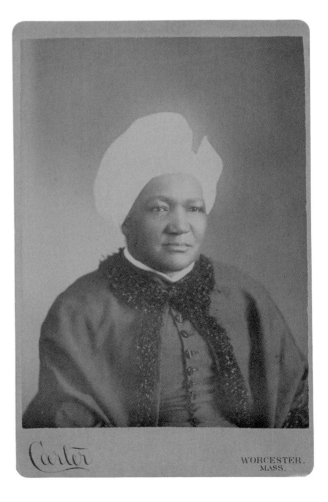

Bachus, 1860s
Unidentified photographer
—

This photograph and documents left by Jameson Moody's family refer to the man pictured here as "Uncle Bachus," a familial term that suggests a level of imagined kinship. During the War of 1812, Bachus was enslaved and served as the personal valet for Moody, the patriarch of a prominent family in Chesterfield County, Virginia. As with many enslaved people, little is known about Bachus's personal life and beliefs. But we do know that as Moody's valet, he was an integral part of the family's life, which this photograph preserved by the Moody family demonstrates.

A man in a paisley vest, late 1840s
Unidentified photographer
—

The daguerreotype above is one of the earliest photographs in the Museum's collection. The daguerreotype process was invented by Louis Daguerre in France and announced worldwide in 1839. A sensitized silver-clad copper plate was placed directly in a camera for exposure, then processed with mercury vapor to reveal the image. The final object is a unique image on the metal plate. The surface of the daguerreotype is highly polished and reflective, and it is often referred to as a "mirror with a memory." American plates are commonly presented in a protective case of wood, leather, and decorative brass elements. The process was popular from 1839 through the late 1850s, until it was replaced by other, less expensive photographic processes.

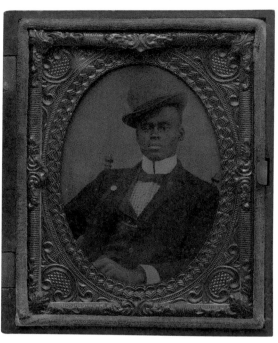

Elisa Greenwell, early 1860s
Unidentified photographer

James Washington,
late 19th century
Unidentified photographer

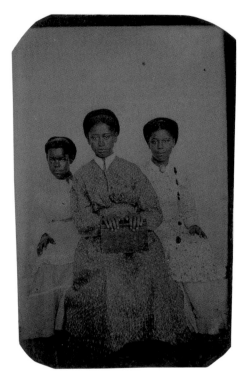 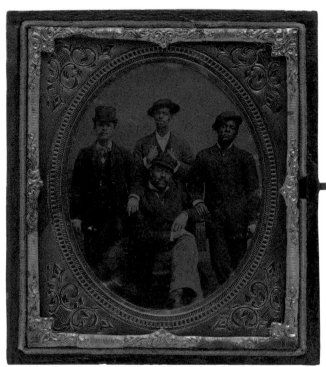

Three women seated,
1870s
Unidentified photographer

Four men smoking cigars,
1855–60s
Unidentified photographer

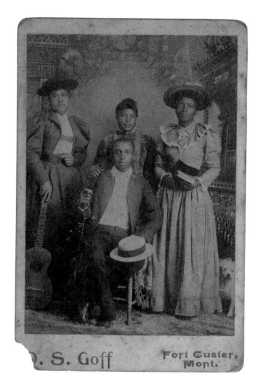

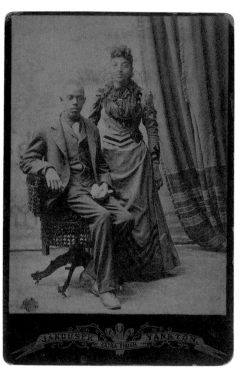

**Three women standing behind
a seated man**, 1884–98
Orlando Scott Goff

**A man and woman in formal
clothes**, late 19th century
Louis Janousek

COMMISSIONING BLACK PHOTOGRAPHERS

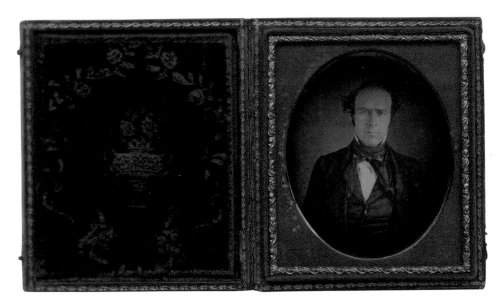

A man, ca. 1850
Augustus Washington
—

Augustus Washington's career combined his passion for photography and anti-slavery causes. Formerly a teacher, he used his business to support his education, first at Kimball Union Academy and then at Dartmouth College. He opened his first studio in Hartford, Connecticut, in 1843, advertising in abolitionist and local newspapers. After a rocky start, Washington's gallery was well established with both black and white clientele by 1850, but he became convinced that African Americans could prosper only in Africa. In 1853, Washington immigrated to Liberia, where he worked as a daguerreotypist, teacher, farmer, and storekeeper.

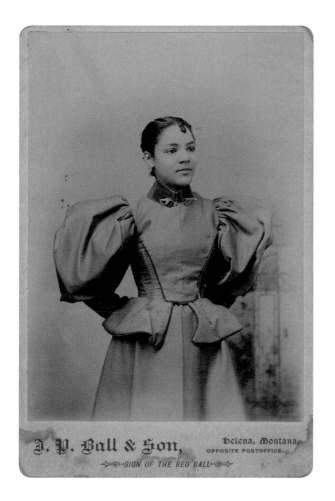

A woman, 1887–1900
J. P. Ball & Son

—

James Presley Ball was a prolific photographer with sitters of all classes and races. When his first studio in Cincinnati, Ohio, failed, he found success as an itinerant photographer in Pittsburgh, Pennsylvania, and then Richmond, Virginia. Ball actively supported the anti-slavery movement and returned to Cincinnati, where in 1855 he exhibited a 600-yard (549-meter) canvas of paintings and pictures exposing the brutality of slavery. Ball set up new galleries in the 1880s where black communities had settled, first in Minneapolis, Minnesota, then with his son in Helena, Montana. Ball then worked for a time in Seattle, Washington, and finally moved to Hawaii, where, after nearly sixty years in the business, he passed away in 1904.

W. E. B. Du Bois, 1918
Cornelius M. Battey
—
Cornelius Marion Battey was one of the most prominent early-twentieth-century American photographers. After working in Cleveland, Ohio, and New York City, the Tuskegee Institute of Alabama hired Battey to direct its Photography Division with the aim of training people for employment. Perhaps because he was less bound by the typical commercial conventions of portrait photography, Battey developed a sensitive style and became noted for his artistic and soulful images. He produced masterful, sought-after portraits of Frederick Douglass, Booker T. Washington, and W. E. B. Du Bois. Some of these he published in the early 1900s in a portfolio titled _Our Heroes of Destiny_.

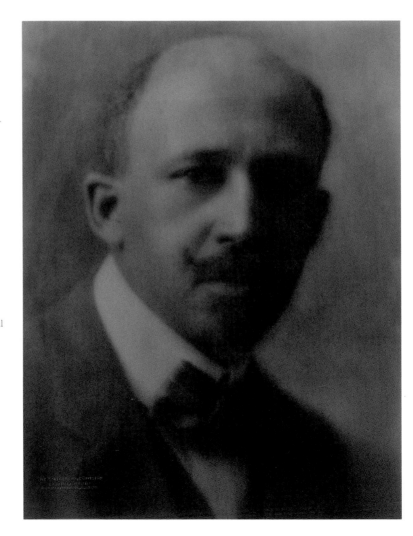

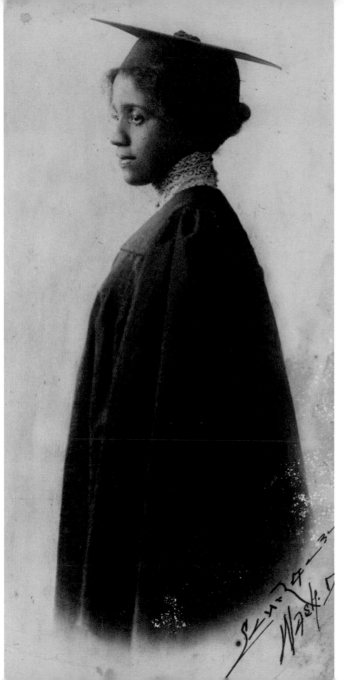

A woman in graduation attire,
1900–10s
Addison N. Scurlock
—

In 1911, Addison N. Scurlock opened Scurlock Studio, which became one of the longest-running businesses in Washington, D.C. At the time, the city had a large black community with many long-established families who became clients. The Scurlock Studio recorded important and everyday moments in the life of Washington's black residents, mainly in studio photographs or at what seems to have been a constant whirl of social events: club meetings, weddings, dances, graduations, birthday parties, and trips to the beach. Scurlock's sons Robert and George expanded the business and ran the studio until 1994.

Sisters of the Holy Family, 1913
Arthur P. Bedou
—

A self-taught photographer, businessman, and journalist, Arthur P. Bedou hailed from New Orleans. He recorded the public and private life of Booker T. Washington as well as life on the campuses of the Tuskegee Institute, Fisk University, and other black colleges and universities. In addition, he is noted for his striking portraits of his hometown's jazz musicians and everyday black life in the South, including this photograph of the Sisters of the Holy Family, a religious order in New Orleans. The Sisters of the Holy Family, founded in 1837, have established and maintained several different ministerial missions, orphanages, and schools throughout New Orleans.

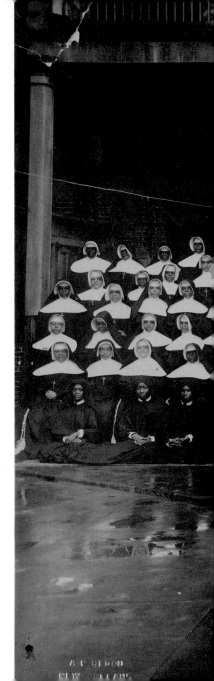

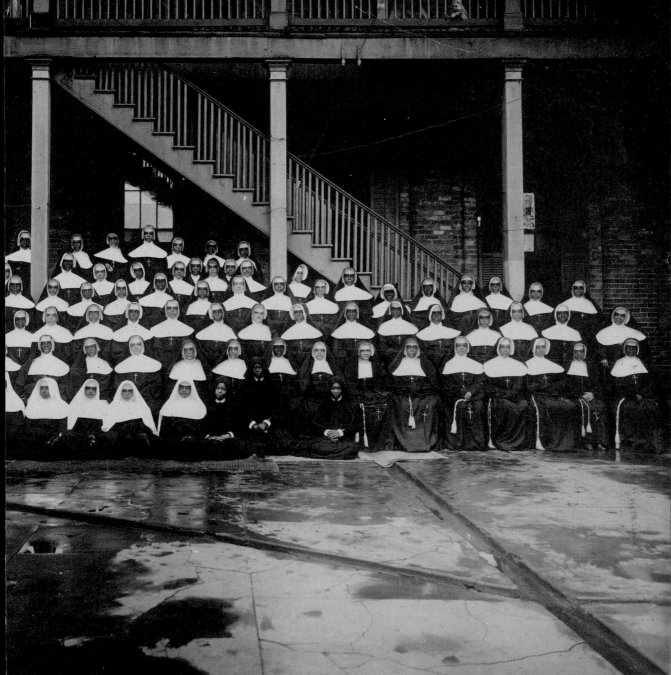

PERSUADING THE PUBLIC

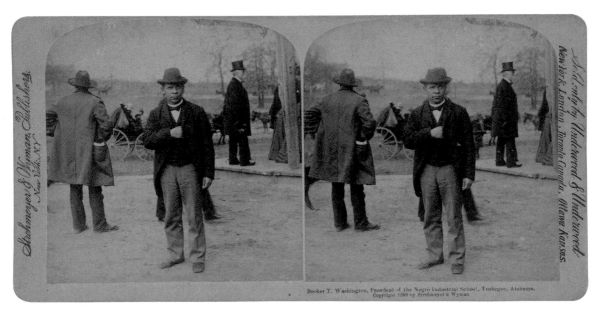

***Booker T. Washington, President
of the Negro Industrial School,
Tuskegee, Alabama***, 1899
Strohmeyer & Wyman

Mary Church Terrell, ca. 1910
Addison N. Scurlock
—

Charismatic figures such as Mary Church Terrell and Booker T. Washington assumed leadership roles and profoundly shaped discourses about race and equal opportunity in their time. Terrell served on the District of Columbia Board of Education—the first black woman in the United States to hold such a position. Consistently active in civil rights, Terrell addressed the National American Woman Suffrage Association, co-founded the National Association for Colored Women and served as its first president, and was a founding member of the National Association for the Advancement of Colored People.

Booker T. Washington (opposite), founder of the Tuskegee Institute, worked tirelessly to secure educational opportunities for ordinary African Americans and advocated for training and skills as the path to their economic advancement. He was an influential author, gifted orator, and trusted presidential adviser.

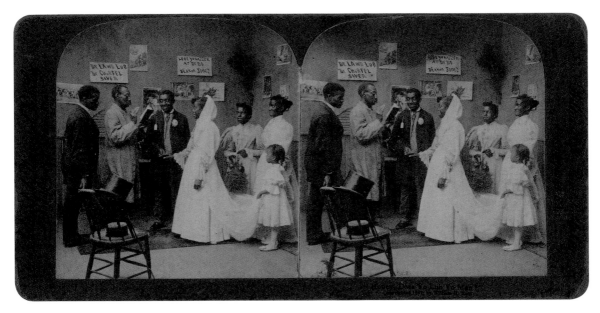

Honey, Does Yo Lub Yo Man!, 1897
William H. Rau

"*[Photography] will either lift us to the highest heaven or sink us to the lowest depths, for good and evil know no limits.*"

Frederick Douglass, 1864–65

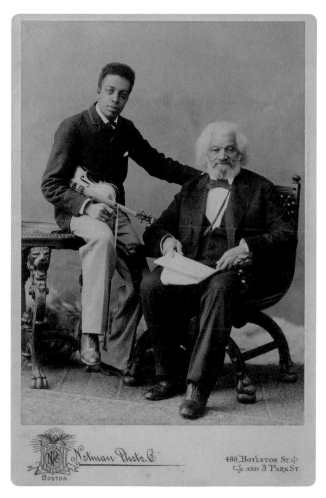

Frederick Douglass with his grandson, Joseph Douglass, 1894
Notman Photo Company

—

Frederick Douglass, the most-photographed man of the nineteenth century, addressed the social significance of photography in his writing and oratory. The many portraits he sat for testify to his understanding of photography's power. Rarely photographed with his family, Douglass is pictured here with his grandson, concert violinist Joseph Henry Douglass, likely on the occasion of a public performance. This image is in stark contrast to popular, mass-circulated photographs like the stereograph opposite, which mock African Americans as painfully inept at practicing social norms.

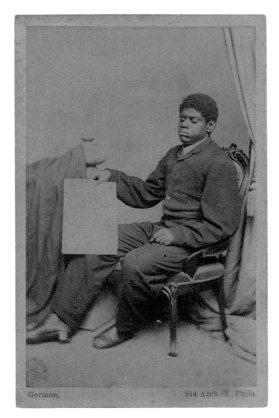

Germon, 914 Arch St., Phila.

Thomas "Blind Tom" Wiggins, ca. 1870
Washington L. Germon

—

These photographs of Thomas "Blind Tom" Wiggins and the Negro String Quartet celebrate and publicize black musicians who enjoyed a broad popular following. However, the careers of Wiggins and Francis Hall Johnson, the most famous member of the quartet (opposite), could not have been more different. A prodigy on the piano, Wiggins is considered now to have been an autistic savant. He was enslaved by James Bethune, who began to promote—and profit from—Wiggins when he was eight years old. Wiggins appears to have enjoyed performing, but he was controlled his whole life by Bethune and others, who made a fortune exploiting him.

At the age of fourteen, after seeing Joseph Henry Douglass perform (see p. 41), Hall Johnson taught himself the violin. In 1923, he joined the Negro String Quartet. The group was hailed for playing both European classical music and new work by African American composers. Devoted to preserving and reinterpreting Negro spirituals, Hall Johnson enjoyed a long, highly successful career as a composer, arranger, musician, and director of the popular Hall Johnson Choir.

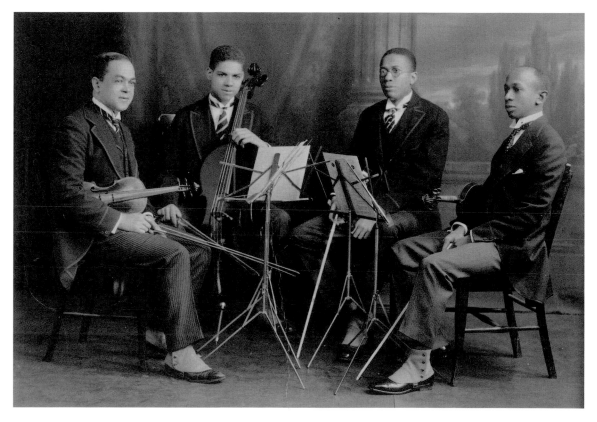

The Negro String Quartet, ca. 1923
S. Tarr
—

Left to right: Felix Wier, Marion Cumbo, Hall Johnson, and Arthur Boyd

Learning Is Wealth: Wilson, Charley, Rebecca & Rosa, Slaves from New Orleans, 1864
Charles Paxson

—

This carte-de-visite produced by the National Freedmen's Relief Association of New York is from a series of images that were used to raise money to educate formerly enslaved people in Louisiana. The image shows the complicated racial dynamics of New Orleans, which had a sizeable mixed-race population. Here, only the seated man appears to be a person of color, but all are identified as enslaved. Although intermarriage was against the law, formal and informal family arrangements were part of the city's social fabric. For example, Rebecca, the older girl pictured, was enslaved in her father's household. The Association depicted light-skinned children to increase support among whites for the abolitionist cause.

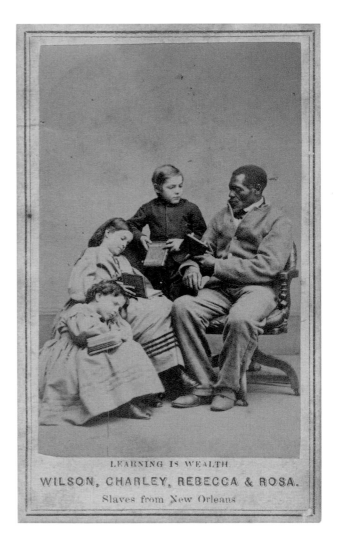

LEARNING IS WEALTH.

WILSON, CHARLEY, REBECCA & ROSA.

Slaves from New Orleans

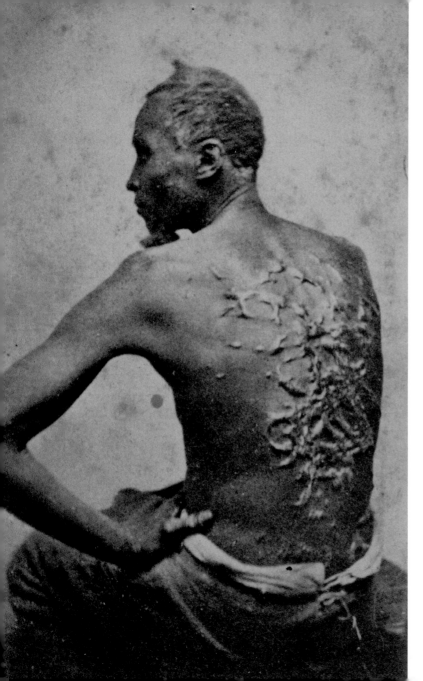

Gordon under Medical Inspection, 1863
McPherson & Oliver

—

This photograph of a runaway slave known as "Gordon," "Private Gordon," or "Peter" became well known as an image documenting the brutality of slavery. This image and *Learning Is Wealth* (opposite) were widely reproduced in popular publications such as *Harper's Weekly*. Enslaved individuals who managed to escape captivity during the Civil War, known as "contrabands," often found safety among the Northern forces. In a note on the back of this photo, an American Army surgeon writes: "I have found a large number of the four hundred contrabands examined by me to be as badly lacerated as the specimen represented in the enclosed photograph."

Radical Members of the South Carolina Legislature, 1868
Unidentified photographer

—

With the implementation of the Reconstruction Acts of 1867, African Americans were given the right to vote and hold office in the Southern states. When South Carolina rejoined the Union in 1868, it became the first state with an African American majority in the state legislature. This carte-de-visite, featuring the sixty-three "radical" members of the Republican caucus, was distributed by opponents of Reconstruction to frighten the white population. Born enslaved in 1822, State Senator William Beverly Nash, pictured here (row five, second from right) and in the campaign button (opposite), served in the State Senate from 1868 to 1877, representing Richland County. Unlike the carte-de-visite here, the campaign button, owned by Nash, demonstrates how an African American during Reconstruction controlled his own image.

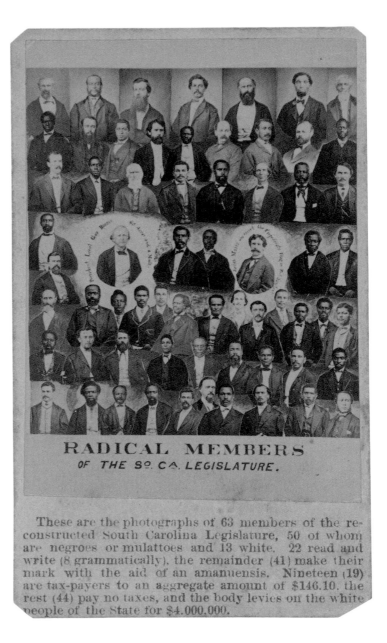

RADICAL MEMBERS
OF THE S⁰. Cᴬ. LEGISLATURE.

These are the photographs of 63 members of the reconstructed South Carolina Legislature, 50 of whom are negroes or mulattoes and 13 white. 22 read and write (8 grammatically), the remainder (41) make their mark with the aid of an amanuensis. Nineteen (19) are tax-payers to an aggregate amount of $146.10, the rest (44) pay no taxes, and the body levies on the white people of the State for $4,000,000.

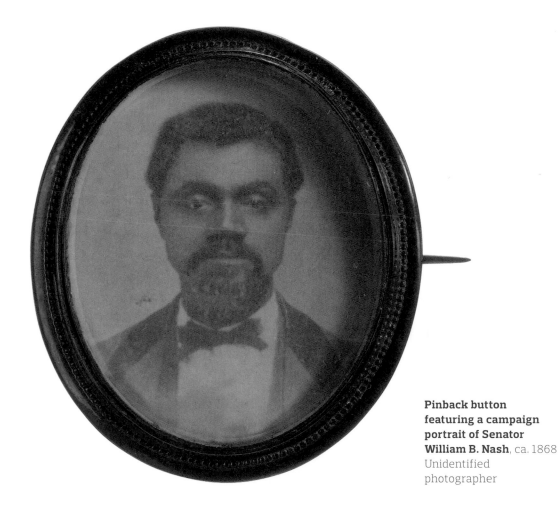

**Pinback button
featuring a campaign
portrait of Senator
William B. Nash**, ca. 1868
Unidentified
photographer

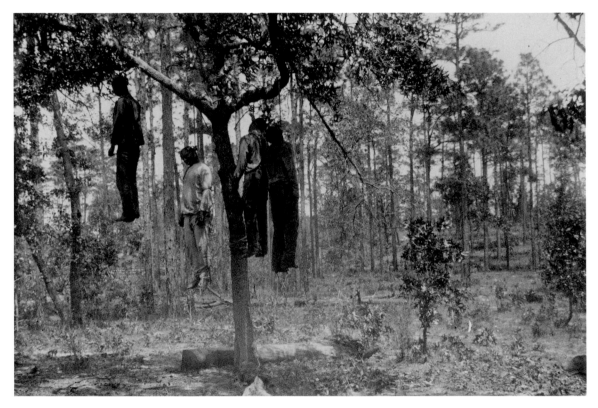

Four lynching victims in Florida, 1892; printed ca. 1901
Dieudonné Liebrecht
—

A mob murdered Jerry Williams, George Davis, Willie Williams, and Albert Robertson in Inverness, Florida, on April 19, 1892.

The Legacy of Lynching Photographs

Often intended as souvenirs at the time, photographs of lynchings documented, and even celebrated, violence against African Americans. Today, they force us to confront a part of the American past that most would rather forget. As an educational institution dedicated to remembering *all* of the American past, the Museum's photography collection includes these disturbing, yet necessary images. They are necessary because they reflect the reality of living in an America that privileged white supremacy. This darker side of the American experience stands in stark contrast to the reality that African Americans crafted for themselves and is evidenced in the dignified portraits they created despite the threat of violence.

One such difficult photograph (opposite) shows four men who were lynched in Inverness, Florida, on April 19, 1892. The men had been implicated in the murders of two men, identified as the foremen of their employer. The victims' bodies were displayed in trees, demonstrating to all the extralegal power of the white mob. These photographs were integral to the tradition of public spectacle that supported lynching as a method of racial intimidation and control; photos and postcards like these were made and shared to convey powerful messages to whites about their racial dominance and to blacks about their degradation.

These public and vehement acts of terror were frequent from the end of Reconstruction in 1877 through the first half of the twentieth century, when, according to the Equal Justice Initiative, more than four thousand African Americans were lynched. Images of violence and destruction of property compel today's viewers to remember and confront these horrific events.

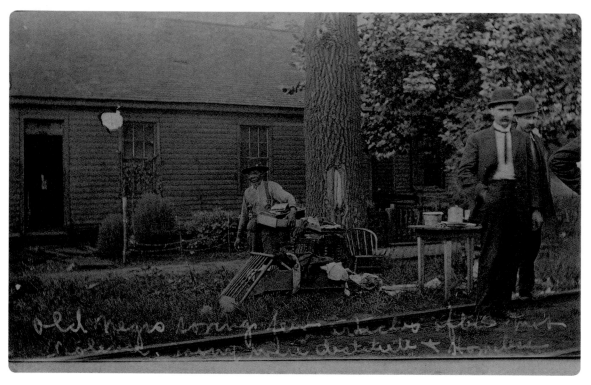

Old Negro Saving Few Articles after Mob Violence. Many Went Destitute & Homeless, 1908
Unidentified photographer
—

In the aftermath of violent attacks on the black community in Springfield, Illinois, many African Americans were forced to leave their homes.

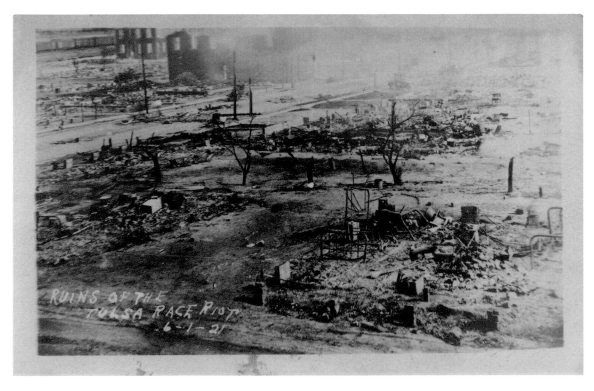

**_Ruins of the Tulsa
Race Riot 6-1-21_**, 1921
Unidentified
photographer
—

This image documents the
Greenwood neighborhood
in Tulsa, Oklahoma, a
prosperous black district
destroyed by a white mob.

DOCUMENTING EVERYDAY LIFE

B. C. Franklin and unidentified men in Ardmore, Oklahoma, 1910
Unidentified photographer
—
Buck Colbert Franklin, the son of a formerly enslaved man, was one of the first black attorneys in Oklahoma. This photograph shows Franklin in front of his office in Ardmore. Later, Franklin moved to Tulsa, where he provided legal services to African Americans. In 1921, a white mob decimated Greenwood, Tulsa's thriving black business and residential district (see p. 51). Franklin, whose home and office were destroyed, helped rebuild his community while working out of a tent.

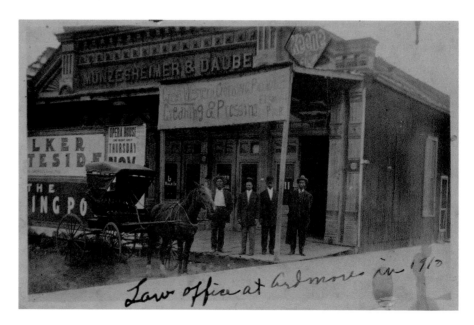

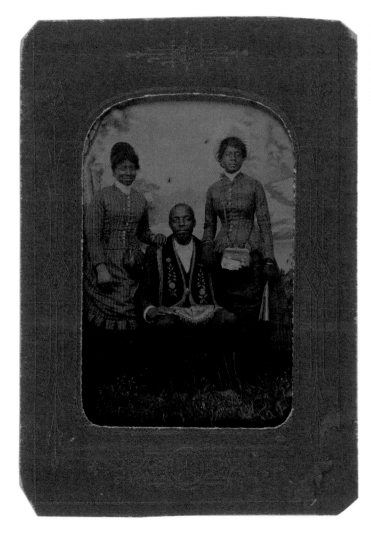

James Turner, Master Mason in the Celestial Lodge of Rhode Island, with two women, ca. 1873
H. G. Pearce

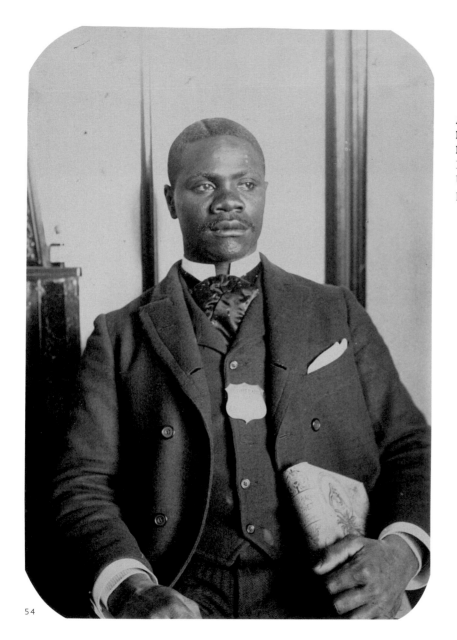

A porter at the Hotel Palomares in Pomona, California, 1885–99
Unidentified photographer

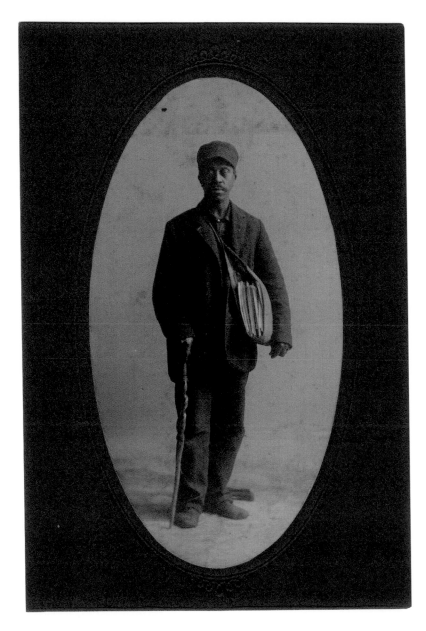

A newspaper carrier,
mid- to late 19th
century
Unidentified
photographer

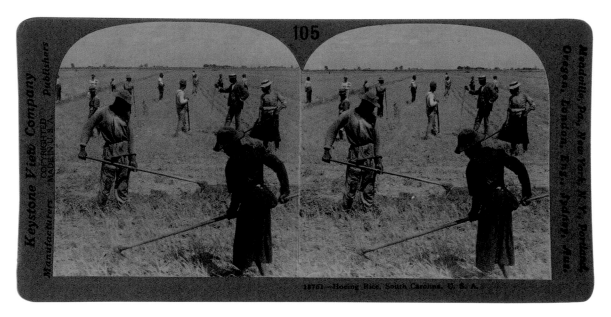

**_Hoeing Rice, South
Carolina, U.S.A._,**
ca. 1904; published
after 1915
Keystone View
Company
—

Stereographs, which show an image that appears three-dimensional when viewed through a stereoscope, gained worldwide popularity in the late nineteenth century. These pictures gave people of all social classes a way to explore the world without leaving home. However, many commercially successful images reinforced stereotypes by documenting everyday life from a white perspective. These two stereographs show African Americans farming rice in South Carolina around the turn of the twentieth century, in much the same way they would have before slavery ended. Such "Old South" images confirmed white biases about labor suitable for black Americans.

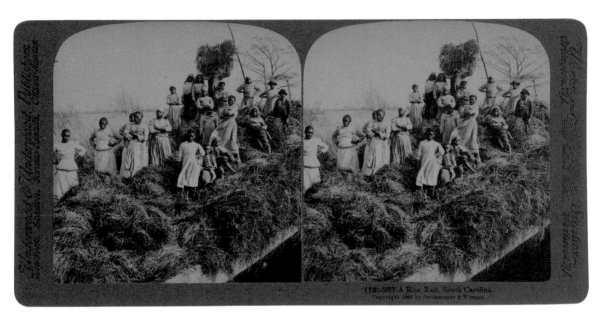

***A Rice Raft, South
Carolina***, 1895;
printed 1904
Strohmeyer &
Wyman

**Workers outside the
Grendel Textile Mill**,
1923–24
Unidentified
photographer
—
During the early twentieth
century, the cotton
industry dominated life in
South Carolina. Over half
of all workers in the state
worked in agriculture,
predominantly in cotton,
and an additional 25
percent worked in
manufacturing, primarily
in cotton mills. Cotton
farming and textile
production was the
life-blood of many small
towns in South Carolina—
especially in Greenwood
County where Grendel
Textile Mill operated. This
panoramic photograph
documents a diverse
group of workers standing
in front of the mill while it
was being rebuilt after an
explosion in 1923.

*"How the past
is documented shapes how
we remember it."*

Lonnie G. Bunch III, 2019

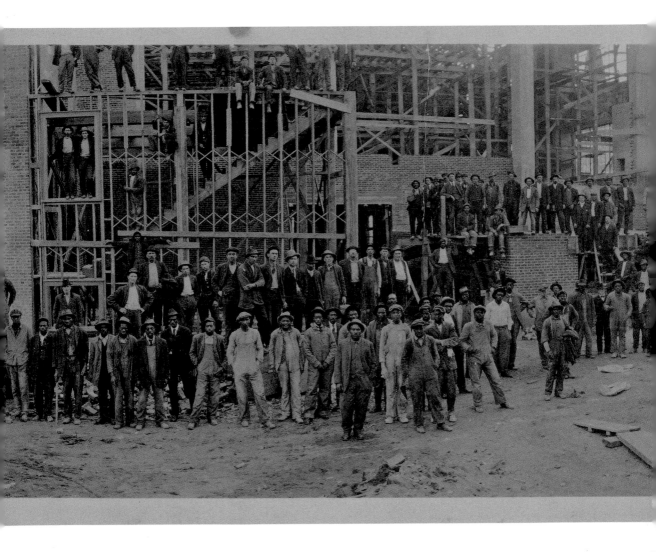

COMMEMORATING ACHIEVEMENTS

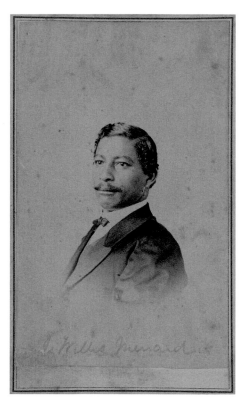

John W. Menard, 1868–70
William H. Leeson
—

On November 3, 1868, John Willis Menard became the first African American elected to the U.S. House of Representatives. Menard's challenger for the New Orleans seat, Caleb Hunt, contested the election. The decision whether or not to seat Menard was put to a vote in the House. The members suspended the rules so that Menard and Hunt could address the chamber in support of their claims. Menard accepted the invitation and became the first African American to address the House of Representatives. However, only 57 of 187 members voted in his favor, and the House refused to seat him.

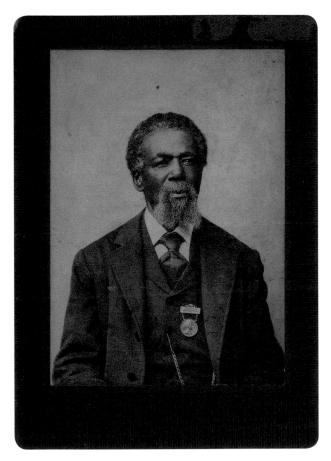

Thomas Mundy Peterson, 1884
William R. Tobias

—

On March 31, 1870, one day after the ratification of the Fifteenth Amendment, which granted all American men the right to vote, Thomas Mundy Peterson became the first African American to cast a ballot in an election under the provisions of the Fifteenth Amendment. Peterson voted at City Hall in Perth Amboy, New Jersey, in an election over the revision of the city's charter. He cast his ballot in favor of revising the charter and was appointed to the seven-person committee that made the revisions. To honor Peterson, the citizens of Perth Amboy presented him with a gold medallion. Peterson is said to have loved the medal and never considered himself properly dressed without it affixed to his left breast, as seen in this commemorative photograph.

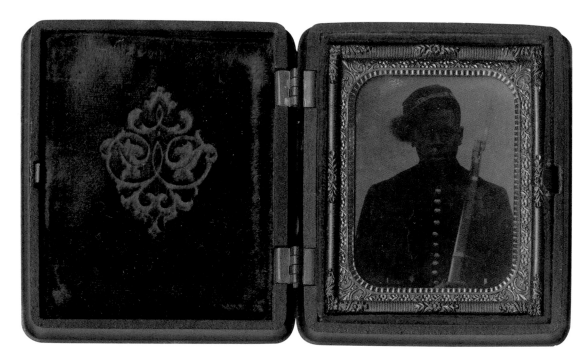

A Civil War soldier,
1861–65
Unidentified
photographer
—

Images of Civil War soldiers highlight the popularity and widespread use of photography during the 1860s. Military portraits and photographs served to commemorate significant moments in personal and national histories. This ambrotype showing a self-possessed soldier in the U.S. Colored Troops staring intensely at the viewer may have been an important keepsake for a loved one left behind.

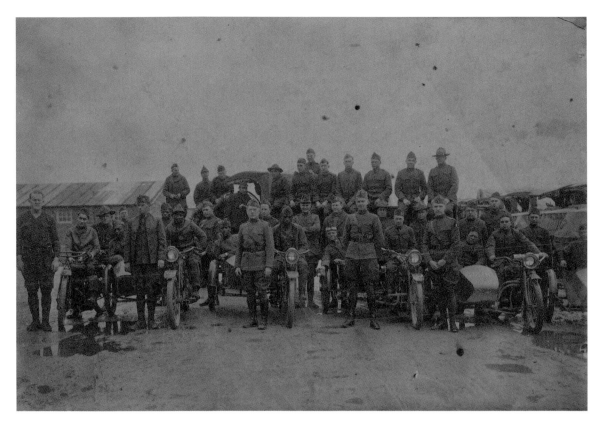

American Expeditionary Forces in France, 1917–19
L. Biaud
—

Historically, many African Americans viewed military service as a gateway to full citizenship and rights. This photograph of soldiers in the American Expeditionary Forces in France marks a moment of racial significance— it shows five African American soldiers in what appears to be a Services of Supply (SOS) unit posing with white soldiers, many years before the American military was formally integrated. Eighty percent of African American soldiers who deployed to France during World War I served in the SOS.

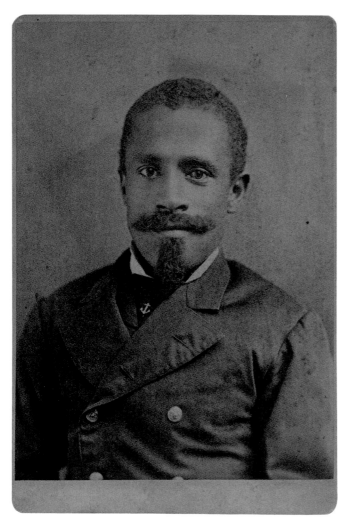

John R. Bell, 1885
David Hinkle
—
John R. Bell was serving in
the U.S. Navy as a steward
to Captain Charles Sigsbee
on the USS *Maine* when
the battleship exploded
in Havana Harbor. Bell
was one of 260 men who
perished as a result of
the explosion.

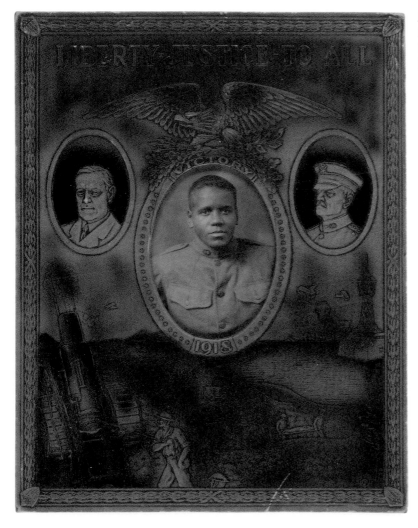

A World War I soldier,
1918
Unidentified
photographer

**Marriage certificate
with tintypes of
Augustus L. Johnson
and Malinda Murphy**,
July 9, 1874
Unidentified
photographer

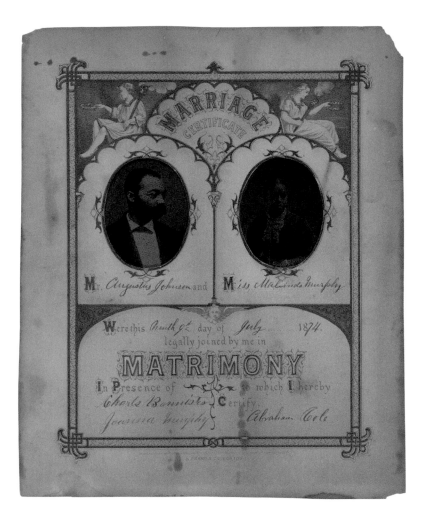

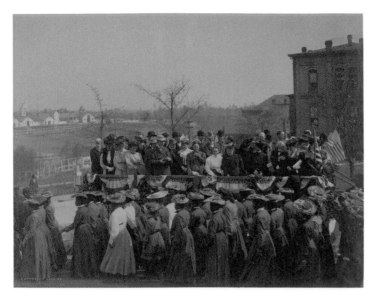

Students and dignitaries at the twenty-fifth anniversary of the founding of the Tuskegee Institute, 1906
Frances B. Johnston

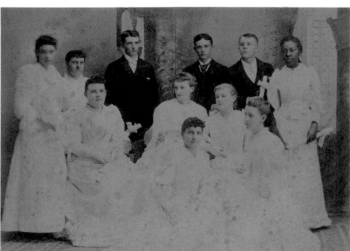

Class of 1892 Oberlin Academy Preparatory School, 1892
Unidentified photographer
—
Eva Dyson was the only African American student in her class at Oberlin Academy Preparatory School. She attended the school on the Avery Scholarship for African American students from 1891–92, before attending Oberlin College on the same scholarship from 1892–93.

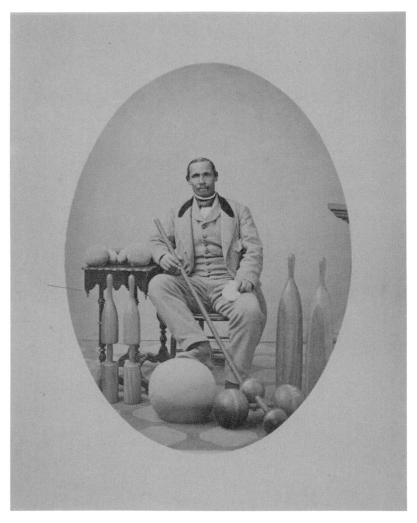

Aaron Molyneaux Hewlett, gymnasium coach of Harvard University, 1859–71
George Kendall Warren

—

In 1859, when Harvard University hired Aaron Molyneaux Hewlett as the director of the University's gymnasium, he was the first African American on the professional staff. He held the post from 1859 until his death in 1871. Hewlett is pictured here for the Harvard yearbook with his tools of the trade: dumbbells, medicine balls, Indian clubs, and boxing gloves.

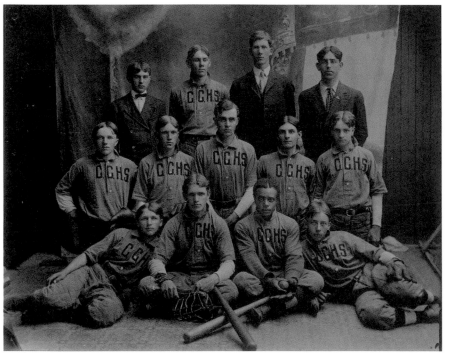

Chase County High School baseball team, ca. 1907
Unidentified photographer
—
Edward Small was the first African American to graduate from Chase County High School in Cottonwood Falls, Kansas. In this team photograph—an early example of an image of school and sports integration—Small holds a baseball and glove. He is seated front row center, which suggests he had an important role on the team.

PRESERVING MEMORIES

Harriet Tubman, 1868–69
Benjamin F. Powelson
—

This earliest known photograph of Harriet Tubman, a dynamic force and advocate for freedom and social change, was taken shortly after the end of the Civil War. The image was discovered in the personal photo album of Emily Howland, a white Quaker, abolitionist, educator, and women's rights activist. In 2017, the National Museum of African American History and Culture and the Library of Congress jointly acquired the photo album.

Emily Howland grew up in a family fiercely opposed to slavery; their upstate New York home was a stop on the Underground Railroad. In the beginning of Howland's career, she was a teacher at the Normal School for Colored Girls founded by Myrtilla Miner in Washington, D.C. From 1864 to 1867, she volunteered as a nurse and teacher at Camp Todd, a freedmen's camp in Northern Virginia. Over the years, Howland formed or funded fifty schools supporting African American education, particularly for girls. Her commitment to equality, social justice, freedom, and education is reflected in her photo album, which contains forty-eight photographs of prominent abolitionists, politicians, educators, and family.

In the nineteenth century, photo albums were a common household item that reflected one's immediate circle of friends, family, and popular figures. The album was given to Howland in 1864 by Carrie Nichols, a friend and nurse at Camp Todd.

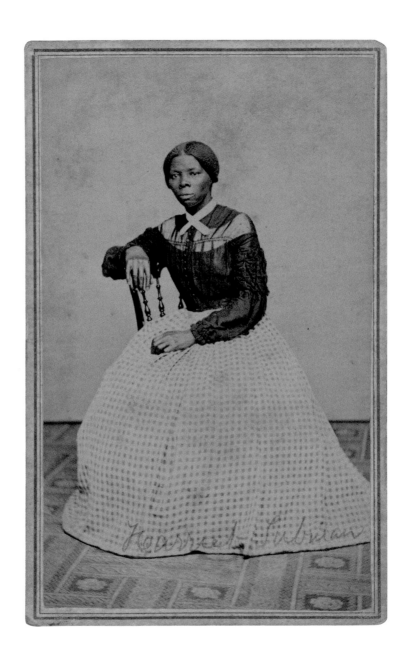

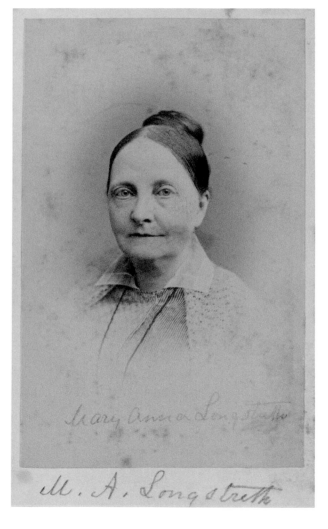

**Mary Anna
Longstreth**, 1870–80
Taylor & Brown
—
Mary Anna Longstreth
was a Quaker, teacher,
and staunch abolitionist.
In the mid-1850s, an anti-
abolition, pro-slavery mob
seized her and brought her
to Rittenhouse Square in
Philadelphia to be hanged
alongside other prominent
abolitionists. She was
saved from death by the
arrival of Pennsylvania
Militia troops.

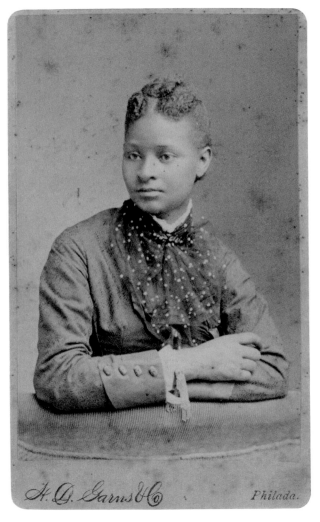

Sidney Taliaferro,
1881
H. D. Garns & Co.

—

Sidney Taliaferro was a
student at the Howland
Chapel School, founded
by Emily Howland in
Northumberland County,
Virginia. Taliaferro, a
protégé of Howland, later
taught at the school.

Rev. G. H. S. Bell, 1894
C. M. Bell Studio
—
These photographs
of Rev. George Henry
Service Bell and his wife,
Susan Bell come from an
album associated with
Waterbury, Connecticut.
Already a minister with
the British Methodist
Episcopal Church, Bell
left to join the African
Methodist Episcopal
(AME) Zion Church in
1880 and was appointed
to Mount Olive AME Zion
Church in Waterbury
in 1892. While there, he
grew the membership
from fourteen to forty-
seven. Waterbury's
black community at
the time was small
but vibrant. Turn-of-
the-century sources
describe performances
of the Enterprise Band,
meetings at the masonic
and Odd Fellows lodges,
union picnics, a cakewalk
contest, and many
church events.

Susan Bell, 1894
C. M. Bell Studio

M. G. Sishuba, 1913–18
Unidentified
photographer
—
These photographs are
from a unique collection
of over one hundred
portraits of African
Americans that provide a
window into the middle-
class community in
Nashville, Tennessee. The
collector, Arthur Melvin
Townsend Sr., a medical
doctor and educator, was
active in many areas of
the black community.
His personal assemblage
of cartes-de-visite and
cabinet cards reflect
his efforts to track and
document the numerous
people representing
his educational efforts
to sustain and support
the race. Overall, the
portraiture shows an
elite Southern black
community that sustained
activities in higher
education, supporting
studies in religion
and medicine.

M. G. SISHUBA

A native of Queenstown, So. Africa, now study-
ing for the ministry at Roger Williams University,
Nashville, Tenn., under the support of Bethlehem
Baptist Association, Chicago, Illinois.

A girl reading, early
20th century
Unidentified
photographer

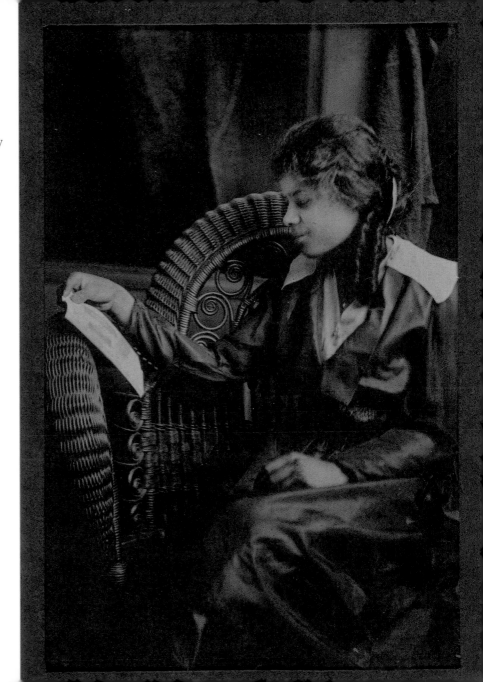

Index

All of the photographic materials are in the collection of the National Museum of African American History and Culture.

McPherson & Oliver
Gordon under Medical Inspection,
1863
albumen carte-de-visite
H × W (Image and Mount):
4 × 2⅜ in. (10.2 × 6 cm)
2011.155.54
Page 45

Notman Photo Company
**Frederick Douglass with his
grandson, Joseph Douglass**, 1894
albumen cabinet card
H × W (Image and Mount):
6½ × 4¼ in. (16.5 × 10.8 cm)
Gift of Dr. Charlene Hodges Byrd
A2010.26.29.8.1
Page 41

Charles Paxson
*Learning Is Wealth: Wilson,
Charley, Rebecca & Rosa, Slaves
from New Orleans*, 1864
albumen carte-de-visite
H × W (Image and Mount):
4 × 2 7⁄16 in. (10.2 × 6.2 cm)
Gift from the Liljenquist Family
Collection
2012.158.30
Page 44

H. G. Pearce
**James Turner, Master Mason,
in the Celestial Lodge of Rhode
Island with two women**, ca. 1873
tintype
H × W (Image and Mount):
4½ × 3 in. (11.4 × 7.6 cm)
2011.57.16.1
Page 53

Benjamin F. Powelson
Harriet Tubman, 1868–69
albumen carte-de-visite
H × W (Image and Mount):
3 15⁄16 × 2 7⁄16 in. (10 × 6.2 cm)
Collection of the National
Museum of African American
History and Culture shared with
the Library of Congress
2017.30.47
Page 70

William H. Rau
Honey, Does Yo Lub Yo Man!,
1897
gelatin or collodion printed-out
stereograph
H × W (Image and Mount):
3 9⁄16 × 7 1⁄16 in. (9 × 17.9 cm)
2015.248.4.2
Page 40

Addison N. Scurlock
Mary Church Terrell, ca. 1910
gelatin silver developed-out print
H × W (Image and Sheet):
7 × 5 in. (17.8 × 12.7 cm)
Gift of Ray and Jean Langston
in memory of Mary Church and
Robert Terrell
TA2017.13.10.2
Page 39

Addison N. Scurlock
**Robert, Addison F., and George
Scurlock**, 1924
gelatin silver developed-out print
H × W (Image and Sheet):
10 9⁄16 × 7 5⁄16 in. (26.8 × 18.6 cm)
Gift of the Scurlock family
TA2014.306.3.10
Page 11

Addison N. Scurlock
A woman in graduation attire,
1900–10s
gelatin silver developed-out print
H × W (Image and Sheet):
9 7⁄16 × 4 7⁄16 in. (24 × 11.3 cm)
Gift of Jennifer Cain Bohrnstedt
TA2015.143.6.3
Page 35

Strohmeyer & Wyman
*Booker T. Washington, President
of the Negro Industrial School,
Tuskegee, Alabama*, 1899
albumen stereograph
H × W (Image and Mount):
3½ × 7 in. (8.9 × 17.8 cm)
2011.155.205
Page 38

Strohmeyer & Wyman
A Rice Raft, South Carolina, 1895;
printed 1904
albumen stereograph
H × W (Image and Mount):
3½ × 7 in. (8.9 × 17.8 cm)
2011.155.172
Pages 13, 57

S. Tarr
The Negro String Quartet,
ca. 1923
gelatin silver developed-out print
H × W (Image and Mount):
7¼ × 11 in. (18.4 × 27.9 cm)
Gift of Dr. Eugene Thamon
Simpson, Representative, Hall
Johnson Estate
TA2013.166.1.1AB
Page 43

Taylor & Brown
Mary Anna Longstreth, 1870–80
albumen carte-de-visite
H × W (Image and Mount):
4 × 2½ in. (10.1 × 6.3 cm)
Collection of the National
Museum of African American
History and Culture shared with
the Library of Congress
2017.30.14
Page 72

William R. Tobias
Thomas Mundy Peterson, 1884
matte collodion cabinet card
H × W (Image and Mount):
7 × 5 in. (17.8 × 12.7 cm)
2015.190
Page 61

Underwood & Underwood
*These Are the Generations of
Ham*, 1895
albumen stereograph
H × W (Image and Mount):
3 7⁄16 × 6 15⁄16 in. (8.8 × 17.7 cm)
2015.248.4.4
Page 18

Unidentified photographer
Bachus, 1860s
tintype
H × W (Image and Mount):
4 13⁄16 × 3 1⁄16 in. (12.2 × 7.8 cm)
Gift of the Mary Moody Northen
Endowment
2014.20.1.1ab
Page 27

Unidentified photographer
**B. C. Franklin and unidentified
men in Ardmore, Oklahoma**, 1910
gelatin silver developed-out print
H × W (Image and Mount):
7 × 9 in. (17.8 × 22.9 cm)
Gift from Tulsa Friends and John
W. and Karen R. Franklin
2015.176.3
Page 52, frontispiece

Unidentified photographer
**Chase County High School
baseball team**, ca. 1907
gelatin silver developed-out print
H × W (Image and Mount):
10 15⁄16 × 13 15⁄16 in. (27.8 × 35.4 cm)
Gift of Tyson D. Arnold
2015.94.1
Page 69

Unidentified photographer
A Civil War soldier, 1861–65
ambrotype
H × W × D (Case open):
3 × 5⅛ × 9⁄16 in. (7.6 × 13 × 1.4 cm)
H × W × D (Case closed):
3 × 2⅝ × ⅞ in. (7.6 × 6.7 × 2.2 cm)
2008.9.2
Page 62

Unidentified photographer
*Class of 1892 Oberlin Academy
Preparatory School*, 1892
albumen print
H × W (Image and Mount):
9 15⁄16 × 11 15⁄16 in. (25.2 × 30.3 cm)
Gift of Christie Hammel
2015.86
Page 67

Unidentified photographer
Elisa Greenwell, early 1860s
ambrotype
H × W × D (Image and Case):
3 11⁄16 × 3¼ × 7⁄16 in. (9.4 × 8.3 × 1.1 cm)
2015.97.4ab
Page 29

Unidentified photographer
Four men smoking cigars,
1855–60s
tintype
H × W × D (Image and Case):
3 11⁄16 × 6 5⁄16 × ½ in. (9.4 × 16 × 1.3 cm)
2011.155.153
Page 30

Unidentified photographer
Frederick Douglass, 1855–65
ambrotype
H × W × D (Case open):
4¾ × 7 11⁄16 × ½ in.
(12.1 × 19.5 × 1.3 cm)
H × W × D (Case closed):
4¾ × 3⅞ × ¾ in. (12.1 × 9.8 × 1.9 cm)
2010.36.10ab
Page 25, back cover

Unidentified photographer
A girl reading, early 20th century
gelatin silver developed-out print
H × W (Image and Mount):
10¼ × 6⅜ in. (26 × 16.2 cm)
2011.36.148
Pages 23, 77

Unidentified photographer
James Washington, late 19th
century
tintype
H × W × D (Case open):
3 × 5⅛ × ½ in. (7.5 × 13 × 1.3 cm)
H × W × D (Case closed):
3 × 2½ × ¾ in. (7.5 × 6.5 × 1.9 cm)
2014.37.10.2
Page 29

Unidentified photographer
A man in a paisley vest, late 1840s
daguerreotype
H × W × D (Case open):
3¾ × 6½ × ⅜ in. (9.5 × 16.5 × 1 cm)
H × W × D (Case closed):
3¾ × 3¼ × ⅞ in. (9.5 × 8.3 × 2.2 cm)
2008.9.15
Page 28

Unidentified photographer
**Marriage certificate with tintypes
of Augustus L. Johnson and
Malinda Murphy**, July 9, 1874
tintypes
H × W (Images and Mount):
11¼ × 9¼ in. (28.6 × 23.5 cm)
Gift of Louis Moran and Douglas
Van Dine
2016.58
Page 66

Unidentified photographer
M. G. Sishuba, 1913–18
letterpress half-tone print on
coated paper
H × W (Image and Sheet):
5½ × 3⅜ in. (14 × 8.6 cm)
2011.36.134
Page 76

Unidentified photographer
A newspaper carrier, mid- to late
19th century
matte collodion cabinet card
H × W (Image and Mount):
6⅜ × 4½ in. (16.2 × 11.4 cm)
2011.155.65
Page 55

Unidentified photographer
*Old Negro Saving Few Articles
after Mob Violence. Many Went
Destitute & Homeless*, 1908
gelatin silver printed-out postcard
H × W (Image and Sheet):
3⅜ × 5⅜ in. (8.6 × 13.7 cm)
2010.36.9.1
Page 50

Unidentified photographer
**Pinback button featuring a
campaign portrait of Senator
William B. Nash**, ca. 1868
photographic process unknown
H × W × D: 1¾ × 1½ × ⅜ in.
(4.4 × 3.8 × 1 cm)
Gift of the Family of William
Beverly Nash
2013.168.1
Page 47

Unidentified photographer
**A porter at the Hotel Palomares
in Pomona, California**, 1885–99
cyanotype
H × W (Image and Sheet):
7⅛ × 6⅝ in. (18.1 × 16.8 cm)
Gift of Julia J. Norrell
2016.181.1
Page 54

Unidentified photographer
*Radical Members of the South
Carolina Legislature*, 1868
albumen carte-de-visite
H × W (Image and Mount):
4 × 2½ in. (10.2 × 6.4 cm)
2016.49.4
Page 46

Unidentified photographer
*Ruins of the Tulsa Race Riot
6-1-21*, 1921
gelatin silver developed-out
postcard
H × W (Image and Sheet):
3⅜ × 5½ in. (8.6 × 14 cm)
2011.175.12
Page 51

Unidentified photographer
Sojourner Truth, 1864
albumen cabinet card
H × W (Image and Mount):
6½ × 4¼ in. (16.5 × 10.8 cm)
2013.207.1
Page 24

Unidentified photographer
Three women seated, 1870s
tintype
H × W: 4 × 2⅞ in. (10.2 × 6.2 cm)
Gift of Jan Kathleen Bourgeois
2014.137.3a
Page 30, front cover

Unidentified photographer
A woman in a striped dress, 1890s
tintype
H × W (Image and Sheet):
4 × 2⅜ in. (10.2 × 6 cm)
Gift of Oprah Winfrey
2014.312.151
Page 6

Unidentified photographer
A woman with a child, ca. 1865
tintype
H × W × D (Case open):
3⅝ × 6⁹⁄₁₆ × ⅜ in. (9.2 × 16.7 × 1 cm)
H × W × D (Case closed):
3⅝ × 3⅜ × ⅝ in. (9.2 × 8.6 × 1.6 cm)
2008.9.16
Page 17

Unidentified photographer
A woman with a child on her lap,
1839–65
daguerreotype
H × W × D (Image and Case):
3¹¹⁄₁₆ × 3¼ × ½ in. (9.4 × 8.3 × 1.3 cm)
2011.155.146
Page 17

Unidentified photographer
**Workers outside the Grendel
Textile Mill**, 1923–24
gelatin silver developed-out print
H × W (Image and Sheet):
7½ × 25 in. (19.1 × 63.5 cm)
Gift of Nancy Adams and Daisy
Holsonback
2012.92
Page 58

Unidentified photographer
A World War I soldier, 1918
toned gelatin silver developed-out
print in original decorative paper
frame
H × W × D (Image and Frame):
14¹⁄₁₆ × 11 × ³⁄₁₆ in.
(35.7 × 27.9 × 0.5 cm)
2011.155.88
Page 65

George Kendall Warren
**Aaron Molyneaux Hewlett,
gymnasium coach of Harvard
University**, 1859–71
albumen print
H × W (Image and Sheet):
13⅛ × 10 in. (33.3 × 25.4 cm)
2014.174.9
Page 68

Augustus Washington
A man, ca. 1850
daguerreotype
H × W × D (Case open):
3¾ × 6¼ × ¼ in. (9.5 × 15.9 × 0.6 cm)
H × W × D (Case closed):
3¾ × 3⅛ × ⁹⁄₁₆ in. (9.5 × 7.9 × 1.4 cm)
2010.52.1
Page 32